The Hill/Adamson Albums

This book has been edited and designed by
The Sunday Times Magazine

The profits from the sale of this book will be
donated to the National Portrait Gallery Trust Fund
for the acquisition and conservation of historic photographs

The Hill/Adamson Albums

A selection from the early Victorian photographs acquired by
the National Portrait Gallery in January 1973

TIMES NEWSPAPERS LIMITED

Select Bibliography

Gernsheim, Helmut and Alison: *The History of Photography* London,
Thames and Hudson, 1969 (revised edition)
Michaelson, Katherine: *A Centenary Exhibition of the
Work of David Octavius Hill and Robert Adamson*
Edinburgh, Scottish Arts Council, 1970
Schwarz, Heinrich: *David Octavius Hill* London, Harrap, 1932
Thomas, D. B.: *The First Negatives* London, HMSO, 1964

First published in Great Britain in 1973
by Times Newspapers Limited Printing House Square London E C 4
Copyright in Foreword and Introduction © Times Newspapers Limited 1973
Copyright in photographs and captions © National Portrait Gallery 1973
ISBN 0 7230 008 67
Printed by Staples Printers Limited, London

Extracts from the Director's Diary

by Roy Strong
Director, National Portrait Gallery

November 29, 1972 The curatorial staff of the National Portrait Gallery first learn, through a notice in the *Evening Standard*, of the decision of the President and Council of the Royal Academy to sell the Hill/Adamson Albums at Sotheby's on December 13.

December 5 The Reverend John Wall writes to *The Times* complaining that historic photographs are not subject to the rules governing the export of works of art. In reply I write:

Sir,
Today's letter from the Reverend John Wall is particularly timely: next week the Royal Academy of Art is allowing its unique collection of photographs by David Octavius Hill to be auctioned at Sotheby's where they are expected to make a price of £30,000. The Academy has taken the incredible decision to do this without consulting any of the national collections or museums interested in photography or portraiture.
However, the position is not quite as bleak as the Reverend Wall suggests. The National Portrait Gallery has, since February of this year, had a Department of Film and Photography and is rapidly establishing archival conditions and practices for building up a national collection of photographs ... All who are interested in the preservation of historic photographs in Britain may rest assured that we will do everything possible to stop these priceless David Octavius Hill photographs leaving this country.
Yours faithfully,
Roy Strong

December 7 On the day on which *The Times* prints my letter the Trustees of the National Portrait Gallery meet. Sir Thomas Monnington, the President of the Royal Academy, attends the meeting in his capacity as *ex officio* Trustee. The Trustees express hopes that the Academy might be persuaded to withdraw the albums from the sale, and instruct the Director and the Keeper of Film and Photography, Colin Ford, to use every means at their disposal to raise funds for the purchase of the Hill/Adamson albums. They pledge their remaining funds, only £3000, as a token bid at the sale.

December 8 The press carry the story of the Hill/Adamson albums. There is a sudden burgeoning of articles on the value of old photographs.

December 9 The Chairman of the Trustees, Lord Kenyon, and I are informed of the Academy's decision to withdraw the Albums.

December 10 The Sunday newspapers have a field day on the subject of historic photographs. *The Sunday Times* prints an appeal to the public to send old photographs to the National Portrait Gallery. The photographic world stirs, passions are aroused. Demands are voiced for a national photographic museum with government support.

December 11 The PRA's letter to *The Times* announcing the withdrawal of the Albums from the sale is published. I write to the PRA expressing gratitude and saying: 'Should they be offered to the National Portrait Gallery, every effort would be made to raise funds for their acquisition . . . our concern is for saving the photographs for a national collection'. The letter is buried in the Christmas post and apparently not received by the Academy until January 4.

Christmas period We work behind the scenes to raise funds and offers of substantial help are received from the photographic industry and the press should an appeal be made.

January 10, 1973 The President and Council of the Royal Academy agree that the albums 'should be offered to the National Portrait Gallery for the sum of . . . £32,178.50. This offer is conditional upon the National Portrait Gallery's producing this sum without a public appeal.'

January 11 Every newspaper carries the story of the Gallery's dilemma—our lack of funds and the embargo on a public appeal. Early in the day a benefactor, moved to action by the account in *The Times*, offers to donate the sum, and immediately I relay the news to the Secretary of the Royal Academy. We decide to exhibit the albums as soon as possible.

January 26 The cheque is at last ready to be presented to the Royal Academy in person by Colin Ford, who brings back the Hill/Adamson albums. Throughout the month the correspondence columns have bristled; conflict within the photographic world has been exposed—in short, everyone has tried to get in on the act, but finally, though tempers are frayed, the albums are secure.

March 6 The exhibition of the Hill/Adamson albums opens at the National Portrait Gallery. Heartfelt thanks are expressed to the donor; to the staff who laboured long and hard; to Robin Wade and Richard Fowler, who designed the exhibition; to Kodak and *The Sunday Times* who made it possible; to Oyez/World Microfilms, who took transparencies for security and exhibition purposes; to Brian Coe who made calotypes to the original formula; to Films of Scotland for *The Sun Pictures* and to Philips Electrical and the other companies who helped us to show it on video-cassette; to those who kindly lent exhibits and to all who got the exhibition on in record time and rushed this book to press.

The Beginnings of Photographic Art

Colin Ford
Keeper of Film and Photography,
National Portrait Gallery

Though the invention of photography belongs, properly, to France, its true flowering was in Victorian Britain. The discoveries of Daguerre and Talbot were announced only seven months after the new Queen's coronation. She, and later her consort too, encouraged the development of the new medium (Victoria often wore a ring with five photographs of members of her family).

Niepce and Daguerre

Photography *ought* to have been invented about 1800. The fact that silver nitrate was sensitive to light was known as early as 1727, and the camera obscura, which reproduced images through a lens on to a sheet of paper or similar surface and was used throughout the eighteenth century, had been in existence even longer. But the two were never married together and the important experiments with silver nitrate of Thomas Wedgwood and Humphry Davy around 1800 achieved little because they lacked a substance to prevent the images they made from fading.

So the first photograph 'from nature' was probably not taken until the summer of 1826 or even 1827, at Saint-Loup-de-Varennes, some sixty miles north of Lyons in central France. The photographer was Nicephore Niepce (1765–1833), who called his process 'heliography'. If his only surviving picture is typical, its results were very indistinct and the exposure time very long (about eight hours in bright sunlight) and the invention aroused no great interest until Louis Daguerre (1787–1851) entered into partnership with Niepce in 1829. Previously Daguerre's main preoccupation had been with the Diorama, and he successfully operated two of these huge painted *trompe l'oeil* light shows in Paris and London (the home of the London Diorama was at 18 Park Square East, close to Regent's Park). To help him paint scenic panoramas for these, he made use of a camera obscura and early in 1837, using a solution of common salt, he succeeded in fixing images on sensitised silver-coated plates. The new photographs, with much better definition and shorter exposure times of twenty to thirty minutes, became known as daguerreotypes. Failing to find commercial sponsorship, Daguerre sold his process in 1839 to the French government who made it available throughout the country; within a year cameras and cameramen were everywhere in France.

Five days before signing the French contract, Daguerre patented his process in England.

'Photogenic drawing'

Niepce's first photograph had been on pewter, Daguerre's on silvered copper. These solid metal plates were not suitable to print from and made 'one-off' pictures. Furthermore, being direct positive processes, they made mirror-image photographs unless expensive prisms were used to reverse them. For photography to advance a negative-positive process was needed.

William Henry Fox Talbot (1800–1877), like Daguerre, used a camera obscura and was fired with the notion of fixing its images. He took his first photograph 'from nature'—like Niepce's, it was of his home—in August 1835. His tiny camera used chemically treated writing paper. The image was only about an inch square and was what we would call a negative. The exposure time required was an hour or two. Talbot was involved in many other experiments, and between 1834 and 1839 his only real progress with 'photogenic drawings', as he called his pictures, was to start making positives by placing a negative on top of a sensitised sheet of paper and exposing this new sheet to light through the negative. Within days of the announcement of the daguerreotype, Talbot was galvanised into action again and worked on enlarging and improving his pictures and cutting down the lengthy exposure times, but his process could not rival the accuracy and sharp detail of the daguerreotype in the eyes of those who saw the whole business as a fascinating way to copy reality, not as any kind of art.

The latent image

Niepce and Talbot exposed sensitised material in a camera until an image appeared, which they then fixed chemically. But Daguerre had discovered that an image was recorded in the camera before it was observed by the human eye and could be revealed by treatment with chemicals (he used mercury vapour). What he had in fact found was the so-called 'latent image', and this, together with better lenses and better chemistry, enabled him to cut down exposure times dramatically, to improve the clarity of his results and, most important, to capture the likeness, in only a few minutes, of living subjects.

Independently, using gallo-nitrate of silver instead of mercury, Talbot discovered the latent image in 1840 and reaped the same benefits as Daguerre. The way was open for the most beautiful photographic process of the nineteenth century, which he patented in February 1841 and called the 'calotype' (Greek 'kalos' = 'beautiful'). The calotype, however, never really caught on, although it was now as fast

as the daguerreotype and, being paper-based, had many advantages over it. This was a result partly of the fascination exerted by the detail of the daguerreotype, partly of the immense publicity which Daguerre had gained as the first to announce his discoveries. But mostly it was because Talbot's restrictions on the professional use of his process suppressed the general practice of calotypy, whose peak of perfection was attained only in Scotland, where it was not patented.

The calotype in Scotland

Talbot, who had been made a Fellow of the Royal Society at the age of thirty-one, was a friend and correspondent of many scientists. Prominent among these was Sir David Brewster (1781–1868), eminent physicist and principal of St Andrews University. Talbot kept him informed of the development of his invention, and finally sent details and even some chemicals which could not be obtained in Scotland. Brewster passed them on to a university colleague, Dr John Adamson (1810–1870), and it was he who took the first calotype portrait in Scotland. The negative in the Royal Scottish Museum, Edinburgh, is captioned in John Adamson's own hand: 'This negative Calotype was taken . . . by Mr Fox Talbot's process, and before he had made it public'.

When Talbot asked Brewster, in 1842, if anyone in Scotland could be persuaded to practise calotypy professionally, John Adamson's brother, Robert (1821–1848), a delicate 22-year-old engineer, was volunteered. He was successfully in business by early 1843 and Brewster told Talbot in a letter written on 3 July that 'Mr. Adamson, who is now established in Edin with crowds every day at his studio, will be very grateful for your kindness'.

David Octavius Hill

David Octavius Hill (1802–1870) was a painter, lithographer and book illustrator. A founder member of the Royal Scottish Academy in 1829, he became its secretary in the following year. In May 1843 he was present at a dramatic moment in the history of the Scottish church, when over two hundred ministers walked out of the General Assembly of the Church of Scotland in Edinburgh and marched to Tanfield near Hill's studio. There they established the Free Church of Scotland, and some days later 474 of them signed a Deed of Demission marking their break from the old church. This event, generally known as the 'Disruption', so impressed Hill that he decided to paint a giant picture of all the participants. Sir David Brewster, himself an ordained minister and also present, suggested that photography would be the best way of obtaining rapidly the nearly five hundred portraits involved. In the letter quoted above, he wrote to Fox Talbot: 'A grand

historical picture is undertaken by a first-rate Artist, to represent the *first General Assembly of the Free Church.* I got hold of the Artist—showed him the Calotype, & the eminent advantage he might derive from it in getting likenesses of all the principal characters before they dispersed to their respective homes. He was at first incredulous, but went to Mr. Adamson, and arranged with him the preliminaries for getting all the necessary portraits'.

So the partnership between David Octavius Hill and Robert Adamson began with the fairly humble aim of using photographs as reference material for a painter to work from, and they were neither the first nor the last to illustrate that photographs taken for such purposes are often better than the works which grow out of them. A striking example is the painting of William Etty, R.A., in the National Portrait Gallery, for years called a 'self-portrait' but in fact a copy, by an unknown artist, of the Hill/Adamson calotype (Vol. I, 7).

Hill and Adamson

Hill and Adamson seem to have found a method of working together immediately: Hill arranged the sitters, the costumes and the backgrounds, while Adamson looked after the cameras and the chemical processes. Thus their early pictures were precisely labelled 'Calotype portrait executed by R. Adamson, under the artistic direction of D. O. Hill'. Their studio was at Rock House, Calton Hill, which during the next four and a half years was to be a hive of activity as photography became Hill's major pre-occupation. The number of pictures they made in that period is usually quoted as 1500 (1400 paper negatives survive today) though it may well have been twice as many.

At first they concentrated on portraits of the ministers who had been at Tanfield, posed individually and in groups exactly as they were to appear in the final painting. Later, they took photographs of the leaders of Edinburgh society and of the distinguished visitors to the city with whom Hill came into contact through the Academy and his other social connections.

Many of the portraits made at Rock House are reproduced in this book. At first sight they appear to have been taken indoors, but, in spite of Talbot's improvements, the materials used in making calotypes were still somewhat insensitive and, in order to keep exposures down to a minute or so, sunlight was essential. The furniture and properties needed for the pictures were therefore set out in the open air on the south-west front of the house and a convincing illusion of an interior thus created. Sitters were usually posed leaning on their hands or on some other support to help them keep still, and Hill and Adamson sometimes made use of the headrest which became standard equipment in portrait photographers' studios

after about 1850. On the negative of Plate 52, 'Revd. J. Julius Wood' (Vol. I, 45), in the Scottish National Portrait Gallery, the re-touched shape of such a tripod can clearly be seen; as it can in one of the Newhaven pictures, 'Fisher Laddies' (Vol. III, 39), where one leg of the tripod has not been painted out at all.

Although Hill and Adamson never left the British Isles, the partners did not confine themselves to Rock House. They went to Durham, where they photographed the cathedral (Vol. III, 74 and 77), and to York Museum to record the scientists present at a meeting of the British Association for the Advancement of Science. They frequently went to Bonaly House, whose owner, Henry, Lord Cockburn, the lawyer, had been a patron and supporter of Hill since his scheme to paint the Disruption first evolved. They took few landscapes, but several Edinburgh city-scapes, notably of the castle with its garrison of troops, and of the Scott Monument (completed in 1846). Most interesting of all, perhaps, were their trips to the fishing village of Newhaven, on the Firth of Forth. James Fairbairn, the minister at Newhaven (see Plate 6), took part in the Disruption and it seems likely that when he was photographed for the painting he enlisted Hill's help for a fund-raising campaign to have the fishermen's boats decked for safety. In any case, these photographs of the fishermen and their boats, of the fishwives, of the narrow cobbled streets and the grey stone houses, are some of the best and most beautiful of Hill and Adamson's work, and are certainly some of the earliest photographs of people in something like their ordinary working conditions.

If Hill and Adamson never left Britain, they clearly did not go to North America for what are sometimes called the first photographs ever taken of a Red Indian. These are in fact of a Scottish (or perhaps Welsh) missionary to Canada, the Reverend Mr Jones, who brought home some souvenir costumes and peace pipes from the Lorette tribe of Canadian Indians. Given Hill's occasional taste for fancy dress (see Plate 61, taken at Bonaly Towers and showing the sculptor John Henning with Lord Cockburn's daughter, Mrs Hugh Cleghorn, dressed as characters from Walter Scott's *The Antiquary*), what more natural than that the Reverend Mr Jones be photographed as Chief Kakewaquonaby (Plate 10), or that another picture of him be romantically titled 'The Waving Plume' (Plate 54)?

The albums

The most common size of Hill and Adamson's pictures was about $8\frac{1}{2}'' \times 6\frac{1}{2}''$ (the size of this book), dimensions which survived as the 'whole plate' photograph. After they had been working for a year or so, however, they began to bind sets of pictures into larger albums. This was obviously a good way to assemble them for presentation or sale (an album would fetch £40 or £50), but it must also

have been to reduce the fading to which calotypes were prone (the alternative was to keep them in boxes). The pictures in the few albums which have survived without having been much opened have retained a deep, rich, brown colour which must have been typical of them all when they were first taken.

In 1846 Hill made a selection of two hundred and fifty-eight of his best calotypes to send to the Royal Academy of Arts in London, dedicating to the President and Members 'these attempts to apply artistically the recently discovered process of the Calotype'. This seems to indicate that though the calotypes were a 'fraternal' gift from the Royal Scottish Academy, of which he continued to be Secretary until 1869, Hill was anxious that London should acknowledge the artistic importance of his work.

The calotypes were mounted one to a page on heavy card and bound into three 24″ × 19″ volumes by Colnaghi's, and the work was completed in 1848. Each volume was titled 'Calotype Studies. D. O. Hill RSA and Robert Adamson'. Volume I contained 'Portraits' (102 photographs), Volume II 'Portraits. Groups. &c. &c.' (78 photographs), and Volume III 'Newhaven Fishermen. Landscapes. Buildings. &c. &c.' (78 photographs). All were dated 'Edinburgh 1843-1848'. The photographs are all captioned in pencil, in Hill's own minuscule handwriting. The Royal Academy put these three albums into their Library (they are recorded in the Library catalogue of 1874), and there they remained virtually unopened until 1967. These are the albums which the Academy decided to sell in 1972, and which were bought for the National Portrait Gallery by an anonymous benefactor in January 1973. Shown to the public for the first time in March 1973 at the Gallery, the albums are perhaps the best preserved surviving examples of Hill and Adamson's work, and the 64 reproductions in the following pages are all selected from them. The captions used are, wherever legible, those in the albums. Some supplementary information has been added in square brackets.

The end of the partnership

The extrovert, energetic Hill kept up a pressure of work during his years at Rock House that was in the end too much for the always unhealthy Adamson. Late in 1847 he retired to the Adamson home in St Andrews and he died there in January 1848, aged only 27. The three Royal Academy albums assembled in that year are a fitting memorial to his vital role in the partnership, for without Adamson's knowledge and expertise, Hill could not solve the problem of fading which was increasingly troubling him, and he gave up photography to return to painting. His monumental 'Signing of the Act of Separation and Deed of Demission' was completed in 1866 and now hangs in the headquarters of the Free Church of

Scotland. When he died, his entire photographic stock was valued at £70 and his obituaries did not even mention his work in photography.

The achievement of Hill and Adamson

Part of the success of early British photography derived from strong traditions of portraiture. Hill brought to the photography of the human face a knowledge, at first hand, of the work of Raeburn and Allan Ramsay, and, from prints etc., of artists from further afield (Hill's brother, Alexander, ran a print shop in Edinburgh). Hill himself spoke of trying to make his pictures look like Rembrandt's, and an affinity is apparent between some of the best Hill/Adamson calotypes and the powerful close-ups of Rembrandt's self-portraits. By prompting such comparisons, Hill was pressing for his work to be placed within a firm artistic tradition and to be judged as art in its own right. So it is clear that the effects which make Hill and Adamson's pictures successful were calculated ones: the careful exploitation of sunlight, the precise disposition of draperies and objects, the emphasis on strong textures in materials and backgrounds. Most important was the concentration on the face itself, always the most forceful and telling part of the picture. None of this could have been achieved with the daguerreotype. Superb at recording minutiae, its metallic qualities made subtle effects difficult; it could not even be looked at properly except in the right light. As Brewster wrote to Talbot: 'The daguerreotype is considered infinitely inferior for all practical purposes, notwithstanding its beauty and sharpness'; and Hill himself wrote: 'The rough and unequal texture throughout of the paper is the main cause of the calotype failing in details before the Daguerreotype . . . and this is the very life of it. They look like the imperfect work of man . . . and not the perfect work of God'.

Hill and Adamson's superb results were never equalled by anyone else using calotypes. Even when the process had been overtaken by better ones, only the Frenchman 'Nadar' (Gaspard Felix Tournachon, 1820–1910) and the English amateur, Julia Margaret Cameron (1815–1879) approached their skill as portraitists. Their merits have been recognised by the various authorities and historians who have rediscovered Hill and Adamson over the last 74 years (beginning with a major Royal Photographic Society exhibition in 1898) and have made the rich and well-preserved treasure hoard of the Royal Academy albums—for how long, one wonders?—the most expensive set of photographs in the world. The real significance of what happened in January 1973 is that these now belong to the public, who will be able to see the originals and reproductions made from these beautiful examples of the work of David Octavius Hill and Robert Adamson who must now be acknowledged as the finest of Victorian portraitists.

To the
President and Members
of the
Royal Academy of Fine Arts,
London.

These attempts to apply artistically,
the recently discovered process of

The Calotype,

Are, with great respect,
Inscribed and presented
by their
Obedient Humble Servant,

D. O. Hill.

Edinburgh,
26. July, 1846.

1 Sandy (?) Linton, his boat & his bairns [Newhaven] *Vol III*, 19

2　The King Fisher [Newhaven] *Vol III*, 11

3 The Beach at Newhaven, near Edinburgh *Vol III*, 3

4 The Sisters Binnie & Miss Monro *Vol II*, 15

5 The Morning After 'He Greatly Daring Dined' [D. O. Hill on left] *Vol II*, 53

6 The Pastor's Visit [Reverend James Fairbairn at Newhaven] *Vol III*, 26

7 Fisher Laddies [Newhaven] *Vol III*, 39

8 Baiting the Line [Newhaven] *Vol III*, 37

9 St Andrews Harbour *Vol. III*, 70

10 Kakewaquonaby, a Canadian chief [the Reverend Mr Jones?] *Vol I*, 83

11 Sisters [Newhaven] *Vol III*, 32

12 John Knox's House, Edinburgh *Vol III*, 51

13 Just Landed [Newhaven] *Vol III*, 38

14 Fisher Lassie & Child [Newhaven] *Vol III*, 21

15 Kenneth Macleay, RSA [miniaturist, founder-member of RSA] *Vol I*, 101

16 Sleeping Flower Gatherers—Study *Vol II*, 75

17 Mr Maitland McGill Cloughton *Vol I*, 81

18 Miss Elizabeth Rigby [who married Sir Charles Eastlake in 1849] *Vol II,* 28

19 Dr Cooke, St Andrews *Vol I*, 13

20 Mrs Murray [wife of John Murray, the publisher] *Vol II*, 6

21 Dennistoun's Tomb, Greyfriars, Edinburgh [D. O. Hill on left] *Vol III*, 40

22 Fishermen at Home [outside the cottage of the Newhaven pilot] *Vol III*, 5

23　Fishermen Ashore [Newhaven] *Vol III*, 35

24 A Study *Vol II*, 62

25 The Marquis of Northampton [Lord Compton, MP and author] *Vol I, 3*

26 Thomas Duncan, RSA, ARA [portraitist and history painter] *Vol I*, 20

27 Charlotte (only child of D. O. Hill) *Vol II*, 73

28 Mr (Robert) Bryson, horologer, Edinburgh *Vol I*, 38 *and* 80

29 Miss Matilda Rigby [sister of Elizabeth Rigby] *Vol II, 27*

30 Newhaven Fisher Callants *Vol III*, 8

31 Two Fishermen [Newhaven] *Vol III*, 30

32 Miss Elizabeth Rigby [later Lady Eastlake] *Vol II*, 22

33 J. Drummond RSA [genre and history painter] *Vol I*, 34

34 A Sleeping Child—E. Logan *Vol II*, 70

35 Mrs Jameson [Anna Brownell Jameson, authoress] *Vol II*, 10

36 Lord Robertson [Lord Patrick Robertson, jurist and author] *Vol I*, 74

37 Tombs in the Greyfriars [Greyfriars Hospital and Cemetery, Edinburgh] *Vol III*, 45

38 D. O. Hill, RSA, W Borthwick Johnstone, RSA *Vol I*, 100

39 Miss Elizabeth Rigby [later Lady Eastlake] *Vol II*, 34

40 Bonaly, near Edinburgh—Lord Cockburn's Residence *Vol III*, 57

41 The Misses Grierson *Vol II*, 66 and 71

42 John Henning and A. H. Ritchie, Sculptors *Vol I*, 24

43 David Roberts, RA [theatre designer and popular landscape painter] *Vol I*, 90

44 Jeannie Wilson and Annie Linton [Newhaven] *Vol III*, 20

45 Edinburgh Castle [with workers on the site of the Scott Monument] *Vol III*, 54

46 John Stevens, RSA [with his sculpture 'The Last of the Romans'] *Vol I*, 93

47 Agnes & Helen Mylne of Northampton *Vol II*, 58

48 Edinburgh Ale—J. Ball, J. Ballantyne, Dr Geo Bell and D. O. Hill *Vol II*, 39

49 Revd Mr Moir & John Gibson [both HM Inspectors of Schools] *Vol II, 52*

50 The Three Sleepers—Sophia Finlay, Annie Farney and Brownie *Vol II*, 59

51 The Scott Monument, Edinburgh [completed in 1846] *Vol III*, 53

52 Revd J. Julius Wood *Vol I*, 45

53 Mrs Anne Rigby [mother of Elizabeth and Matilda Rigby] *Vol II*, 30

54　The Waving Plume [The Reverend Mr Jones?] *Vol I*, 94

55　The Fishmarket, St Andrews *Vol III*, 68

56 The Covenanters' Tomb, Greyfriars [Edinburgh, D. O. Hill on left] *Vol III,* 41

57 Miss McCandlish, Edinburgh [later Mrs Arkley] *Vol II*, 14

58 Mr Liston, Surgeon [Robert Liston, FRS] *Vol I*, 91

59　Dr Geo Bell, Miss E. Bell and Rev. Thos Bell *Vol I*, 97

60 Mrs Anne Rigby & Miss Elizabeth Rigby *Vol II*, 32

61 Study in Bonaly—Edie Ochiltree (Henning) & Miss Wardour (Miss Cockburn) *Vol II*, 56

62 A Fisherwoman [Newhaven] *Vol III*, 17

63 Fisher Laddies [Newhaven] *Vol III*, 4

64 The Minnow Pool, Children of Mr Charles Finlay, Edinburgh *Vol II*, 69